Book Title: Little Art Book, Big Ideas.

A book from the life-work of artist, writer, traveller, jerry Gordon

gordonart is a trade name *est.* 1990
www.gordonart.co.uk*est.* 2002
gordonart Ltd: registered company *est.* 2007

Produced by gordonart Ltd - original text by the author unless referenced otherwise. Research is provided and quotes used are acknowledged.

artist asserts moral copyright no part of this publication may be reproduced or held on a retrieval system without prior permission of the artist and gordonart Ltd.
© copyright the artist
www.gordonart.co.uk

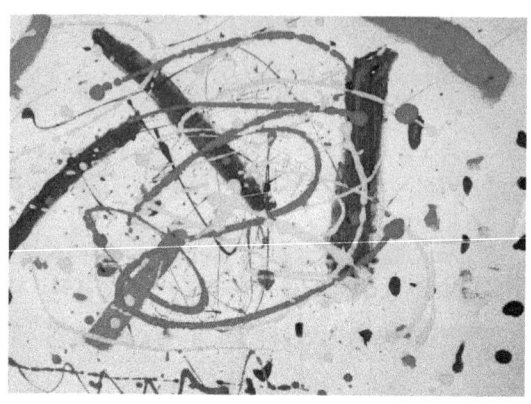

Front-piece – acrylic on paper 24" x 36"

*Everyone discusses my art and pretends to understand, as if it were necessary to understand, when it is simply necessary to love....**Claude Monet***

Forward

Digest this little art book and you will know what art is and who the artist is. *Jerry Gordon* has cooked up an easy-to-remember recipe of three words for the artist and three words for the artwork - short and sharp, brilliant. Additionally he describes some basic things about art. For example, he explains the meaning of colours in easy to understand language.

He has written books for five years, studied art in London for ten years, exhibited paintings for twenty five years and travelled widely for forty years.

He has helped me with my books, so it is an honour to write this *Forward*. If he was a chef he would have expensive *Michelin* stars - and this serving maybe cheap-as-chips but it is very tasty, treat yourself, **Dick Fleetwood.**

Contents

Forward

Preface

Introduction

1- The Artist – Three Things

2 –The Artist - 10 pointers

3 - Art - Three Key Things

4 – What Art Is - 10 Pointers

5 - Time

6 – Biography

7 - Art and the Artist in a devoted circle

8 – Art is Love and Love is Art

9 - Art Unifies

10– Art gets into the Community

11 - Art and the Law

12 - Art and Suffering - four points

13 - Is the Front-piece Art, was it painted by an Artist?

Colour Annex

Other Books

Figures

Front-piece – A painting

Fig. 2 **Homage to Pollock** (after Whistler), The Author

Fig. 3 **Copy of a Picasso**, The Author, Charcoal

*One ought, every day at least, to hear a little song, read a good poem, see a fine picture, and, if it were possible, to speak a few reasonable words **Goethe***

Preface

I believe that the world needs art. The world would be very grim without art. Art needs artists to make it. I aim to tell you what art is and who the artist is. I think it will assist you whether you are a student of art or general reader, **Jerry Gordon**

*Painting is possessed of divine power, for not only does it make the absent present, but also makes the dead almost alive.....***Leon Battista Alberti**

Introduction

Little Art Book, Big Ideas hinges on what art is, and the artist that made it. I've written about art in other books such as, 'Colour Theory made Fact - *the Daubs*'. I refer to that book and include some of it about colour in this book.

Artists have a deeply engraved gift for spotting what others don't see. Artists make art that acts like a mirror, it reflects back at us and our experience. There are many mediums that do this such as, architecture, sculpture, acting, film, music, photography, (some cooking). I focus on painting mostly.

I have supplied three basic words to describe who the artist is and three words to describe what art is. In the final chapter I ask a question about the abstract painting at the front of this book - is it art? If you can answer that

you can apply it to any artwork, and thus you find this little book to be a trusty companion.

*I have always tried to hide my efforts and wished my works to have the light joyousness of springtime, which never lets anyone suspect the labors it has cost me....***Henri Matisse**

1- The Artist – Three Things

The artist has three key elements, *talent, love, care.* You can remember that with *TLC.* The artwork created by the artist then stands on its own. *TLC* needs to be in place. If elements are missing, the work will suffer. If any of those attributes are absent it will not be art. Why should anyone bother about the piece if, for example, the artist does not care? Who should *love* the art if the artist doesn't? Talent on its own is not enough. Any two out of the three elements is no good. Why should anyone else *love* or *care* if the artist doesn't? They shouldn't, it isn't art.
Apply *TLC* when trying to work out whether an artist is an artist or not.

A question, is the Front-piece art? I will expand that question in the final chapter.

I support leisure-time artistic creativity, and projects organised by teachers, community leaders. The world is a better place because of such things. But art may not be the result. Such projects may come about because the people involved *care* and *love* the project, but if, say, *talent* is missing the results will diminish with time – it will not be art. Some projects hold great meaning to the community whether art has been produced or not, this is understandable. Many school and local authority arts projects can be like this. For instance, the huge colourful image in the school reception area, a collage made from broken tiles, maybe stupendous and loved by all, but that does not mean that it is art.

Equally, a would-be artist may feel driven to try and make art - an all consuming passion. Such a person maybe dedicated to art and lives for art, but they may not be an artist. Trying to make art is very honourable. Sometimes a person decides they are an artist and have lots of love and care about art hugely, but if they do not have talent

they are not an artist.

Art will only be produced by a person who has *TLC*, an artist.
And, art will definitely be produced with *TLC* in appropriate proportions. If they are in place, it is art, and others can contemplate elusive thoughts as a result. That is what art does; it helps to encourage deep and powerful thoughts, feelings, and later actions. To re-iterate, when *TLC* is genuine and in good proportions art is made by an artist.

*A person is born an artist as a hippopotamus is born a hippopotamus; and you can no more make yourself one than you can make yourself a giraffe......***John Ruskin**

2 –The Artist - 10 pointers

TLC in place who is the person entrusted with such responsibility to make art? Here are ten pointers:-

- To have an intense personal motivation

- To know profoundly what a vocation is

- To be prepared to be an agent of change

- To know love after learning what it isn't

- Preparedness to struggle through adversity

- Acceptance of failure and success as equals, but aiming and preferring success

- To know the work of forebears & peers

- To maximise the capacity to be productive

- To learn about technical innovation

- To be incorruptible

*Every work of art is the child of its age and, in many cases, the mother of our emotions. It follows that each period of culture produces an art of its own which can never be repeated....***Wassily Kandinsky**

3 - Art - Three Key Things

Art comprises of three key elements, *skill, time* and *devotion. STD* is an easy way to remember that. So in addition to the *TLC* of the artist, there is *skill, time, and devotion,* the attributes of the artwork.

The community will agree that it is art when the above components are clearly evident. There maybe disagreement on style, but there will be agreement when it is obvious that skill, time and devotion have been used to create it. The art will be of the time, but also transcend time, and is created by devotion and will arouse devotion in the audience.

Looking at art, *TLC* and *STD* are arts secrets.

But some art is more powerful than other art. For instance, with the greatest of art made by the greatest of artists, then appreciation can become dependence. For example, the *Louvre,* Paris, depends on huge numbers of people visiting to see the *Mona Lisa,* by

Leonardo da Vinci. The *Mona Lisa* is one of the world's generally acknowledged art-icons. We in turn depend on the arts business to promote the greatest art. We need to know such great human achievements are possible. Art inspires us to achieve. We rely on that quality in our daily lives - to know that we humans are capable of great achievements. High benchmarks can inspire us to aim high.

Not all art can be as great as the *Mona Lisa*. Some works of art are stronger than others, but all true works of art find a place in the world.

Every major town and city has an art gallery drawing people in to see art; some of it is great art. As suggested, some art is less great, but if it has *TLC* and *STD* it is art nevertheless. We need art. Life would be unthinkable without art. Without art we are doomed.

When I sit down to make a sketch from nature, the first thing I try to do is to forget that I have ever seen a picture.... **John Constable**

4 – What Art Is - 10 Pointers

- It is often beautiful, but not always

- Is pattern & subtle variation of that pattern

- It shows the artists' talent, love & care

- It is capacity for the work to arouse devotion

- It is accepting of the passage of time

- It arouses thought & debate

- It is between subjectivity and objectivity

- It shows the artist has a belief system

- It is to do with the context the artist lived in

- It is concerned with the community

*The creator of Plato's physical world is not a divine intelligence though divine mechanic.....he is an artist but not the creator of new form, but the translator of pre-existing form.....****Plato's Cosmology: The Timaeus, The Demiurge (Creator)***

5 - Time

We need art to include time. Time is related to all things. We compartmentalise things in pockets of time - that is what we do. It helps us understand things better. Placing things in time-frames helps us put things in perspective and we stay sensible as a result. If we didn't use time to put order in our lives we'd be shaken up too much by all the change that goes on with no way of boxing things up. We need stability and art helps us achieve that, and time helps us know what art is. For example, we have just come through a millennium, a transition period from one millennium to another. There is not much writing about how art is changed by Millenniums but there is about centuries. Some writers like Holbrook Jackson believed that some special changes, like waywardness, occur at the end of centuries.

There are others like the philosopher Schopenhauer with his *The World as Will and Idea* (1819) who said oppositely that

we are living as part of a continuous existence. So change exists at anytime, and is always relative to the times, and not necessarily at rims of time.

Nevertheless, some writers and artists enjoy wrapping up things for the last decade of a century. Part of this flourish includes decadence. For example, artists like Aubrey Beardsley (1872-98) made many erotic drawings during the mid 1890s, and naughtily illustrated work like *Salome* for Oscar Wilde. Wilde himself is forever linked to the 1890s not only because he wrote some hugely influential material, but that he promptly died in 1900. Brit art at the end of the 1990s also showed a fascination for decay and renewal.

The French in the 1880s coined the term *Fin de Siecle* not only to describe the end-of-century exactly, but more of a cultural phenomenon linked with it. Trends studied by academics in England for many centuries confirm some themes and cultural phenomena related to this. A unique verve exists at the end of centuries; the French example describes a type of melancholy highlighted

especially by the arts focussing on the exotic, and the decadent.

Beyond art, generally, a heightened sense exists amongst people to do with how old orders are rung out, and new orders come in. By-products take shape in many professions but art is a major signifier.

Important to the *Fin de Siecle* idea is that everything is moving and conforming to a greater narrative.

These curious periods that extend to ten years either side of the big cusp – so in our time 1990 - 2010. But of course in our example we are talking about how Millenniums end, and as suggested, there isn't much study done on that yet.

I believe that when we use time measurement in art we are talking about a visual representation of managed-change. Better look back to gain a sense of comfort for experiencing the 'now'. Better look back in gaining courage for where we are going in the future - art is so helpful in helping us see this.

*The position of the artist is humble. He is essentially a channel.......***Piet Mondrian**

6 – Biography

Biographical information about the artist is required to be in the public domain. This is because truthful biographical details confirm accuracy of the artist's life and career. There are some artists who are referred to as *Anonymous Masters* but these are far and few between. Most artists are known for lives lived as well as their artwork.

Material penned by the artist in autobiography is valuable material because it is coming from the proverbial horse's mouth. You can't get more direct than that.

A critic dips a pen into the blood of the artist as a mosquito drills a proboscis, and although the outcome may sustain a food chain, the artist is made sore. A critical appraisal, on the other-hand, provides a balanced survey of a specific piece, or the *oeuvre*. A fair critical appraisal, (including both negative and

positive aspects), will be accepted by the artist.

Another dependable author can write a biography, but it will be their truth, not necessarily the artist's truth. A talented biographer will aim for truth, and this prevents distortions that can arise by some writers' who may hold negative ideas. Truth is needed as a base-line for understanding the artwork as time goes by. Though, ultimately, it will be your truth that counts.

A biographer can detail an artist's life and work. A fair biography will include facts like education, work, relationships, but also describe the artist's experience of these events.

A biography maybe unauthorised. If it is authorised it is written with the permission, cooperation, and at times, participation of the artist or the artist's heirs.

*It is necessary to mark the greater from the lesser truth: namely the larger and more liberal idea of nature from the comparatively narrow and confined; namely that which addresses itself to the imagination from that which is solely addressed to the eye.....**JWM Turner***

7 - Art and the Artist in a devoted circle

I will expand and explain why the artist and art are linked in a devoted circle of activity. I will also provide this formula: artist -> artwork -> beauty/sublime -> transcendence -> moral assessment ->artist.

Sir Ernst Gombrich wrote about what-art-is and what-it-is-not in the 20th century. He said words such as art doesn't exist only artists do. This echoes with the philosopher, Hegel's view too. I will paraphrase Gombrich and Hegel in four words; *no-spirit-no-art*.
My short mantra requires an explanation for the word *spirit*. I use spirit by meaning that it arouses an idea of something big. It is a beyond-ness of

things, or transcendence. When transcending we must recognise that. For example the aesthetic qualities of art that is beautiful or sublime provoke you to go beyond, to transcend. The beautiful is often associated with *classicism* and the sublime is often linked to the *gothic.*

Aesthetic meanings of beauty and sublime were popular in the 18th century. Philosophers like Kant, and Burke made those proposals. Hegel relied on Kant. Basically transcendent feelings are aroused by beauty and the sublime.

Two thousand years earlier Plato identified that beauty might be an intrinsic quality of an object and that could be measured under categories. He called them integrity, harmony, perfection.

By the 18th Century came the *Age of Reason.* Everything was up for discussion. Systematic investigations and increasing moral assessments took place. Moral assessments belonged to cognition, which in turn require reasoning. Making judgments derived

from reasoning. This was a basic systematic order.

My formula above illustrates the artist and the artwork in a profound connection.

If the item of artwork in question does not complete the above circle, it indicates art is absent, it is therefore not art. If it completes the circle for you, then it has more chance of being art.

And it all took time to make, and we are able to think about big timely schemes through art, and that is why we are devoted to it.

It is good to love many things, for therein lies the true strength, and whosoever loves much performs much, and can accomplish much, and what is done in love is well done……. **Vincent van Gogh**

8 – Art is Love and Love is Art

Art in the first place comes from love. When we say love we can disagree on the meaning of the word. Let me be clear;

> *love* is what motivates artists' to extend themselves; to capture a work for others to view, with the additional motive of caring about the other person's spiritual growth; for humanity.

My short hand version of the bigger debate is this, without love there is no art. I go further and say that without art there is no love. Art brings us together.

*It is lack of confidence, more than anything else, that kills a civilisation. We can destroy ourselves by cynicism and disillusion, just as effectively as by bombs....***Kenneth Clark**

9 - Art Unifies

This shadowy difficult world is more tolerable, more understandable by the existence of art. Art because of its spiritualised nature points the way to a more permanent, enlightened existence. Many communities share this belief, and this can be verified judging by the evidence of their art.

To uphold the community is a reason why art gets made. Art is for you as you are part of a community – near or far.

The community often calls on the artists to produce art. Sometimes the artist acts in isolation. Whether the artist is recognised and integrated into the community and paid regularly, or whether the artist is isolated and secluded, if the outcome is art, it will naturally find a way to the general public's attention. We will know that it is art because it will have *TLC* and *STD*.

Art sometimes complies with the instinctive human need to bring people

together. For example this can be for politics, religion, power, trade. Art encourages community stability whether for secular or for devotional practice; art unifying. For example, the biggest exhibitions attract hundreds and thousands of people. This magnetic-pull of art is one of its properties, one of its functions.

*....art can function as a vehicle, that it isn't just a cultural pursuit, something that happens in art galleries. Unless art is linked to experience and the fear and joy of that, it becomes mere icing on the cake......**Anthony Gormley***

10– Art gets into the Community

To answer this we can look at history but also modern society as well. For example, politicians, and popes, monarchs and merchants have commissioned artists throughout time to make art. It continues to this day.

In the 21st century we refer to the arts-industry that is churned around in a sophisticated hungry media machine. Most towns and cities have flourishing art galleries that rely on temporary exhibitions as much as permanent collections of art work.

Many local authorities, for example, commission artists to create sculptures to live in the open-air, and at specific geographical locations, Gormley's *Angel of the North* is an example of this.

Art courses at colleges and universities have multiplied many hundred-fold over

recent decades. Private galleries, auction houses and the world-wide-web provide platforms for the arts business.

Thanks to such momentus activity local communities now expect to see art in village halls, town and city centres and venues and across all media on a daily basis. Meanwhile private collections grow and new collectors join the arts business every day to keep things vibrant. Art finds it way into this arena. Art settles-in as deemed by critique and public agreement. This might not happen in the artist's lifetime.

People will believe the artist when they can see that the artist gained trust. The artist gains trust by producing a work of art. People also need to know that the artist had a right to produce the art work in the first place. The art work is made on their behalf.

Trust in the art work and the artist is obtained in two basic ways. By critique and general agreement. People will react to art and this will be understandable. People will praise art and criticise art that actually is not art.

An artist is not paid for labour, but for vision ...
Whistler

11 - Art and the Law

The artist often tries to support custom and practice but also tries to break new ground. Art needs to have an edge. But radical moves can upset convention. A good example of this fitful progress is the experience of the American artist James Whistler, (1834 – 1903).
At the end of the nineteenth century in Victorian England the British art critic and essayist John Ruskin, (1819 – 1900), was horrified by Whistler's painting of a firework descending over the river *Thames*. Ruskin said that Whistler's flick's of paint was not art this was art was for art's sake.
The proceedings took place at the Old Bailey London. It was a widely publicised test-case of 1877. Whistler had taken Ruskin to court for defaming his expressive right and night time painting of the great river near Vauxhall Bridge, with the offending rocket denoted by flicks of paint.

Whistler won the case and awarded a farthing in damages. He was unfortunately bankrupted as a result, but Art for Arts sake was now safe.

Art, thanks in part to Whistler, had been freed by law.

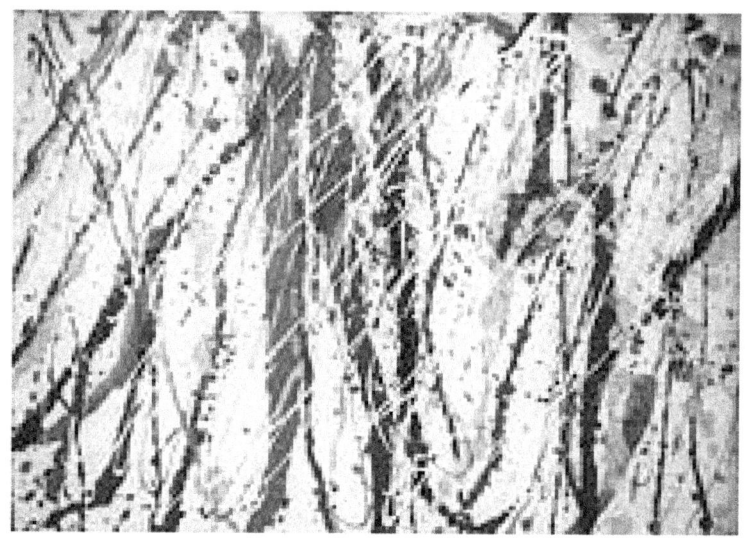

Fig. 2 **Homage to Pollock** (after Whistler), Author Oil & Household Paint on board 48x64cm

Years later this led to Whistlers fellow countryman Jackson Pollock (1912 – 56) being able to flick, fling, or drip lots of paint at his canvasses. He was free to do so.

*The more they measure, the more they realize how much the Greeks departed from regular and banal lines in order to produce their effect **Pierre August Renoir***

12 - Art and Suffering - four points

Alice Miller, in her 1990 book *The Untouched Key* discusses Hitler, as well as Chaim Soutine, Buster Keaton, Picasso, and Kath Kollwitz in relation to childhood trauma.

Miller tackles several key issues in respect of how trauma affects destructiveness, and yet in turn can inspire the creative processes. For example, Chaim Soutine was beaten in childhood, which distorted his world views. He actually spent time being dangled upside down as punishment. His later masterpieces echo this distorted reality. Soutine converted negativity into something beautiful. By Miller's work we can say that creating art is a therapeutic process. But equally in the case of Hitler and by using *TLC* we can safely say his paintings are not art

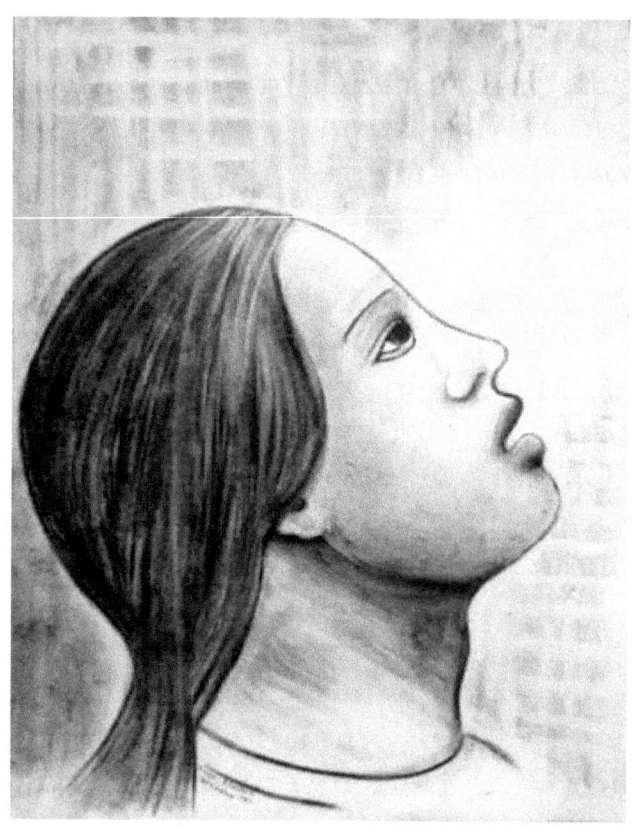

Fig. 3 Copy of a Picasso, Author, Charcoal

because they are profoundly vacant of *love*.

In the 19th century Leo Tolstoy reckoned that as far as art was concerned, that if people lacked the capacity of knowing art, they might be more savage. No art no love. They would be separated from one another, more hostile to one

another. He confirms the nature of the beast – to strike fear, divide and rule. Set against this are the light rays of art; Art that by its angelic imperative, unifies.

Since humans have come into existence we are connecting with nature. Through interaction with nature, humans create art. Art is then entwined with the complexity of the universe. I propose that;

- art cannot exist without an idea of what art is

- all art lay within the art of nature

- humans have a natural connection with nature

- by making connections via art are humans naturally braided with the universe.

Colours live a remarkable life of their own after they have been applied to the canvas ... **Munch**

13 - Is the Front-piece Art, was it painted by an Artist?

Front-piece painting was made in 2014 at the *Hope Mill Studio,* Manchester. It was made by an enthusiastic painter and I had the privilege of seeing her paint it. It was a totally absorbing period of time, and completed within one day. That is as much as I want to say because I hope to invite you to utilise the basic formulas that I have proposed in this book, *TLC* and *STD,* to see whether you can discern if the painting is art and whether you estimate the person who painted it to be an artist? If you did so, and then if you wanted to provide feedback, I here invite you to do so and email <postmaster@gordonart.co.uk> and it will be my intention to publish the results.

I was going to end the book here, then I thought that the use and meaning of colour is so entwined with art. Therefore

I have included the following annex that provides some meaning of colour.

Footnote.
Hope Mill this iconic 217year old building, the red-brick city's first cotton mill built 1797 - from red bricks. This five story slate roof icon was one of the world's first cotton spinning factories following Arkwright's prototype of a modern factory, Cromford Mill, 1769, in nearby Derbyshire. The working space of the *Hope Mill* studio reverberates with Manchester's creative industrial history, and the world's need for clothing.

For information, this is the same place where my arts company recently published an adult Manchester novel that is rapidly becoming a favourite, *'Dodgie's Dead Red Fans - a Manchester Massacre'*, by the Lancashire novelist, Dick Fleetwood. The *Manchester Evening News* newspaper had advertised the book in June 2014. This adult crime story puts Manchester at the heart of the gory matter.

*.....who wishes to become a master of color must see, feel, and experience each individual color in its endless combinations with all other colors.......****Johannes Itten***

Colour Annex

Blue

Blue as pigment has had a history of being a rarity, and so expensive to create as a working medium. This is because the best-blue came from expensive *lapis lazuli*. What needed to happen was the time consuming process of grinding and purifying it. This went ahead with difficulty, (men who organised the grinding of it needed paying!). Purifying operations added to the time-consuming process to eventually get that special blue. Some of the best *lapis lazuli* is from Afghanistan – brilliant of colour and robustly holding its pigment.

A cheaper option was to get blue from two easier sources from the mineral azurite (Armenian stone -> lazurium {Persian word} -> azurium -> to give us the word 'Azure') a copper ore found across Europe. This had been a source

used during, and from *classical* antiquity.

Another alternative; an Indian vegetable product called Indigo that provided an inexpensive source. Indigo was more easily got from a variety of vegetable sources and woods too. In Britain, for example, there had been Woad which had been used for a long time. European Azure is sometimes referred to Citramarine, to distinguish it from ultramarine - ultramarine which came from that precious *lapis lazuli*. It was used to denote precious values in painting because it was precious, for instance, in many a Virgin Mary painting - she often appears in a blue robe.

But blues were needed in quantity for many a mural painting, involving large areas to be covered. Blue would have to come from a cheaper source for that, like Indigo. But Indigo is not resilient and so loses its strength over time – you get what you pay for. This is part of the reason why when we look at *Classical* works of art with lost colour and blue, then we have to bear in mind that likely *lapis lazuli* was not used.

Prussian blue is one of the first blues to be synthetically produced, and for some reason when used without mixing, it suffers from a flatness like no other. But when mixed with, say, white and yellow – wow its a big blue.

Some painters like Van Gogh found that it made a good reference for line against his yellows and oranges. It can be found to make a good green when mixed with a light yellow, but otherwise it has an overly dense quality, which can dominate the scene. This can be good when dominating the scene is what the blue is needed to do, say with the depiction of a wave like in some Japanese depictions of waves. Care is therefore required with its use, to ensure that it does not take-over, unlike its more accommodating family members, such as Cerulean and Cobalt blues and others – produced in great quantities nowadays - readily available for painters in tubes as with the others of the colour range.

Blue is also associated with tradition, caution, fulfilment, dedication, forethought and introspection. Blue does not judge, it accepts. Blue is a colour which, aids contemplation because of its remote quality.

Blue has no perimeter fence; it is the antithesis of its generally accepted opposite and complementary colour, orange. And, because of its omnipresence blue is a binding-force and appears in large proportion, of not only the worlds-flags but in most paintings ever painted.

Red

Red is present in elemental form, notably cinnabar. It can be got from many types of clay, oxides of iron, and notably there is a specific source called Minium (a Spanish river) and this has been highly prized. Red (& orange)-lead has been used from *Classical* times and is widely found in, and throughout the middle-ages. For painting purposes the ancients derived a red from a variety of earths sources, red ochres in particular. The best was reckoned to be from *Sinopia* and the Greeks and Romans valued it highly.

Then Mercury from cinnabar – mainly from Spain and Italy - in the 3rd century AD was obtained, as alchemists had learnt, to procure it by depriving cinnabar of sulphur. Mercury and

sulphur then re-synthesised themselves and vermilion came about. This process was routine by 800 AD. The problem with vermilion got this way is that it can turn black if overly exposed to sunlight. In pursuit of another red, the *lakes* came about from resins and grains from trees (some from Indian gum, lacca–lakes a common derivative name).

In England, oak trees were a source of red as a reaction between resins and dead insects found around holes. Similarly in the middle ages, a similar process came from the Brazil tree. Of this era came Madder – which helped in making the *lakes* - from a field plant that grows in Italy. Another was called Dragons-blood from an East Indian shrub.

In painting, a rule is, the-nearer-the-warmer, the further-the-cooler, so red can be used to differentiate between items of distance thus aiding perspective. For example, the depiction of a red garment to warm a foreground, set against cooler more distant hues, such as blue. The figure in the robe can then jump out from the picture. Then, when it is layered and set against other colours like blue, it helps the design of a

picture. This can help to tell the story the painter wants to tell - tricks of the trade.

Giovanni Bellini and Titian knew this, and with their *Feast of the Gods,* 1514-1529 they show this interplay between blue and red magnificently.

Yellow

It is not light itself, but rather the transporter of light. In earlier times, it came about from orpiment - a sulphide of arsenic. It could also be got from the crushed gallstones of certain sea creatures, like the bile from tortoises. From volcanic, sources too – notably from Vesuvius, hence *Naples Yellow.* Then, compounded solutions of the metals Lead and Antimony provided a yellow also. Another yellow known as Mosaic Gold came from Tin - another by mixing Mercury and egg yolks, to yet another coming from the crocus Saffron. Nowadays yellow paint can be made from an array of both organic and synthesised compounds.

Yellow means different things in different places; in the West, for instance, it was associated with yellow-belly or

cowardice; probably because it could be got from bile. However, notably in China, yellow is a colour which speaks of courage and wisdom.

So, yellow is very generous, as it adapts to different circumstances, and like most energies that extend themselves for the benefit of others, it can sometimes suffer as a victim of this selflessness. This is partly because it can get over-powered by other colours, by Red, for example. Yellow can have taken its sociability too much for granted and ultimately will suffer for it, and so in such circumstances yellow will simply disappear. This may account for some of the criticism laid at its door, like calling it a coward, but this is unfair for the reasons given – Yellow ain't no coward. And, put another way yellow is sensitive and dislikes becoming overly mixed. It gets muddied easily thus loses it brilliance quickly. To remain exciting it needs to be placed in studied proportions, this will avoid its loss.

When Yellow is respected by other colours it quickly thrives on its basic duty. Other colours get the lift they very often need in order to embellish the

scene; but usually at the expense of Yellow. Respecting yellow is a ploy.

Yellow was used interchangeably with gold from the earliest of times, so it is a generally held authentic messenger of the gods. Manuscript illuminators used it in big measures in order to replace gold when that ran out; so yellow came toward the viewer as a messenger. Yellow is so generous.

Orange

The light spectrum's neighbour of red, orange is also derived as a solid from similar processes as red is. It possesses a cheerful nature, and is of course the name and colour of one of the world's favourite fruits. It is a colour that has a tangy character. Picasso painted many oranges, certainly in his early years, and being a Spaniard says much about the associative qualities of the Orange fruit - Spain, one of the world's biggest producers of oranges.

But, for all its friendliness it has sometimes to accept loneliness. Orange suffers as a result; in addition it has a tendency to be on its own because it is an introspective colour and that is why it

complements the expansive blue, its opposite. Orange can be very friendly to other colours but only when in the right proportions. It is often paradoxical because of this. On the one hand it can evoke movement and willingness to mingle, on the other it can imbue calm. It gains as self confidence because of this dexterous ability; and can get over-confident and aloof. But, again, in the correct proportions and with the correct balance of hue it has many practical applications. It is no surprise that a multi-national telecommunications network has adapted it as the main motif *Orange* for such reasons – self assured yet sometimes lonely, autonomous yet friendly! The same summary could apply to the Dutch international football team - they play in orange.

Stronger neighbour's, like, say, Red, will not easily push orange around. It is therefore to be viewed as being quite resolute. And, when applied in the right amounts, accompanying other colours such as gold and blue it can offer a spiritual stance. So again, manuscript illuminators used it, (notably alongside blue), to convey certain narratives of theology. And, in studied proportions,

orange makes a cordial host, pardon the pun.

It is probably no coincidence that orange features in the national flags of Ireland, India, and Western Samoa. And in the case of the principality of Monaco, it is the dominant colour. So Orange is sociable, but probably only ever truly shines when treated with the deference it hankers after.

Green

Like yellow it does naturally possess universal qualities, but overwhelmingly green is the colour belonging to earth. The great landscape painters all knew of how green helped tell a bigger cosmic story, while at the same time a girding to earth.

On finding equilibrium, greens mesh in harmonious ways. Yet just before that, when working out compositions for paintings, green announces itself immediately assisting the painter. Because balance is vital, too much green, or too little, becomes obvious. Once equilibrium is sorted out however, green just sits there and quietly meditates while assisting bigger

contemplation of the earths relationship with the ethers.

Green can be gleaned on earth from a variety of sources such as from Malachite, a green mineral (in conjunction with its cousin azurite, a carbonate of copper), to green earths called Terre verte. From acetates and salts of copper, to sap-greens from berries, from Iris greens (from the Iris flower) to mixed greens which are composites of a selection of the above; then, to nowadays in many synthesised versions.

Ironically, despite its abundance, green is an elusive quarry for painters to capture. Trying to mix it to a suitable hue fit for purpose is usually quite difficult to achieve. This is a paradox, on the one hand there's plenty of scope with its use, and there's plenty of it, but on the other hand, getting the right shade is difficult to capture, as most landscape painters will testify - there are a million leaves on a big tree and each one has individual tinges, but overall green.

Green can be jazzed-up with other colours like orange next to it to make it a more exciting spectacle. And green is

rarely offended by such improvisations, even by bold dashes of red, (it eats them up) but it would rather just sit there and enjoy the view. Green has no circumference, as say, the more urban orange does. You can't imprison green. You can try, but the result will be discomfort as it needs the outlet of going beyond its confines for it has that bigger story to tell.

Playing around with balance provides the opportunity for endless permutations whether in town where actually it is finally captured, often by brick walls and wrought iron - or more easily in the countryside where it runs more freely allowing for those more massive linked up ideas – from earth to the sky. Green tries to help.

Green is friendly and restorative, and viridian green is thought by some to contain the highest amount of such inspirational green properties. This is because viridian mixes easily, but, also because of its innate power it can lift other hues without a complaint. This phenomenon can be seen to be true when mixing it to some yellow and a small amount of titanium white. Lift-off; it comes at you, as Kandinsky might

explain, because of the energy lift it actually gets from yellow – that carrier of light. Red with green, no matter how boisterous, will go cool long before green ever attempts to heat up.

Purple

Purple is similar to violet but gleaned from separate sources and so has different properties. Purple, as a solid colour, can be got from shellfish dye, such as whelks, but is made in quantity nowadays as a synthesised colour - a composite of red and blue.

Violet, on the other hand, appears more often, naturally, and not least in the light spectrum - purple doesn't.

Violet conveys degrees of frailty and humility whereas purple has brashness, a vanity about it. Violet can be helpful to people, who, and for whatever reason, are considering spiritual matters, whereas purple can sometimes mask the line between earth and heaven.

Hence purple can be used with a dubious intent, perhaps in order to try and overwhelm unsuspecting and or vulnerable ones, those designated to be

impressed. The Roman Empire knew this, so adopted purple ceremonially to embellish the dress of legions. Purple has that artificial aspect to it, and no matter how many modern day monarchs use it to sway over people, eventually, in such circumstances, it will be seen by the discerning for what it is; at a minimum decoration, at maximum that barrier to communication.

But when used in balanced and discreet proportions, purple is one of the most tasteful, elegant, and cultured of hues. It can emit either warm or cool properties depending on the respective amounts of its red and blue genes.

Yellow, its opposite, will often feel complemented by being in its close vicinity, but it is fair to say purple needs yellow, more than yellow needs purple. For, yellow has violet and blue to dance with too, as well as other colours such as red. And poor purple knows this and can be envious.

So, to enhance a painting, purple must be handled sensitively and in poised proportion. This might sound obvious but too much purple is obvious.

Violet

Violet lives at the end of the light spectrum. Or, depending which way you look at it, at the beginning too. So violet, is associated with transition for it is where endings and beginning are. It is thus used in religious ritual to denote times of change. So, violet can possess a link to spiritual growth and to substantiate this claim, it can often be used as clergyman's clothes whether in real life or in paintings.

Violet can be utilized to great effect because of this quality of refinement, say in a receding sky-scape. Turner showed a subtle use of it in his painting of *Norham Castle* c.1835-40, as it evokes many atmospheric laments.

Violet as a solid colour, can be got from vegetable sources corresponding to alkalines from chalk or lime, as well as nowadays derived synthetically. Violet occurs in nature in plants, flowers, and semi-precious stones, and does occasionally court criticism because of the very fact that it is precious and refined; a bit snooty.

Indigo

Indigo has close association with blue, for as a dye it is a source of blue. It occurs naturally as a colour in the light spectrum as Newton discovered, but as a solid as Goethe preferred It is a colour that can be extracted from a variety of vegetable sources.

Indigo has several contrasting properties, from utter darkness to an innate light and can act as a bridge between these two extremes similar to violet. Indigo can perform this seeming magical act as Van Gogh showed, using it much, as he did, with looming skies in his paintings done when he was in an asylum in Saint-Rémy 1890.

As though indigo sits by a turnstile, confirming it as a gatekeeper, providing both entry and exit to this earth, a land that can enable spiritual enlightenment, if you believe it to be so. Goethe believed so, a clue to which he referred to as 'secrets' that he referred to in his letter to Runge.

Indigo is an introspective hue, more so than its neighbour blue is, thus is prone to isolation. Hence, I would cite Van Gogh's experience again of suffering much loneliness, and which can

occasionally lead to obsessive humourless pursuits, leading to some melancholia. But, there are paradoxes, because indigo shows us that it is also an innately warm colour, which can thus offer salvation when cold is about. This can be evidenced when used, for instance, as dyed clothing. So indigo has an inherent duality about it, its foot in both hot and cold camps.

grey
A painter can love grey for its altruism because grey is all give. Many a yellow, orange, red, green, and blue has been flattered with a plain grey on a canvas. Canaletto (1697-1768) made a prosperous career from this.
Naturally grey appears in great quantity in clouds, rocks, metals, seas, thus we can get an insight into its vocation – it's a sacrificial colour. It helps define others. Grey is reliable and can thus cultivate a loyalty from brighter hues who want to be seen to shine next to it. Although grey does not balk at this heroic role, it does nonetheless occasionally harbour visions of grandeur for itself, and imagines being embroiled in the excitements caused by

brighter friends. But grey is misguided when it has such heady ideas.

Thankfully grey is mostly sensible and a sober colour and soon realises that ultimately such flaunty ideas are only ever exactly that, whimsical forays of fancy. At the end of the day grey settles in to its familiar more intrinsic monotone restraint.

To understand grey more fully, you have to look at greys parents, so what colours were mixed together to arrive at this grey and to what extent? Was the child-grey in front of you a blend of black and white mums and dads? Or was its ancestry a more complicated mulch of blues, browns, violets, and reds?

The character of the grey will of course speak of its parentage. Naturally, what you put in determines what you get out. For instance, a blue-grey will be more generous and less particular than a red-grey and this is because of what we know of blues more gregarious influence. The painter needs to know this if a painting is to be a resolved one.

True, grey can be criticised sometimes for its mediocrity, but despite this some vibrant colours consider their best friends to be grey after the party is over.

Clever colours know that youthful bright and breezy hues eventually look to grey for meaning, to make sense of their world. But grey will still get criticised for being dull and, incredibly some critics of grey may even be other greys themselves, who may have been living a life, hitherto, of denial and self-delusion. This can happen to grey; it is one of its faults. Sometimes it is unable to stand back and see the quarry for the slate. Ultimately, however, grey wins out with doses of self discovery forced onto itself by monotony; for in that boring state, and just as life itself is a mystery, grey starts asking questions of it-self – sooner or later, usually later. But it gets there because fundamentally grey is a security seeker. And, although it loves nothing better than having an emerald next to its slate, even if only temporarily, it is when in the company of other greys where true happiness lay. Might be boring, but it is a contented boring.

Occasionally a grey having learnt its purpose in life – which is to be a steadying influence may discover pleasure. That after all the monotony it may luckily occupy a position within a bigger field of grey near to a colourful

boundary line, thus gets to live the best of both worlds. A rock near a green field, a boulder on a golden yellow sandy beach, a section of slate by a turquoise lake, a grey metal covered in bright paint. Ah, now that would be bliss.

Brown
Manganese, ferric oxides, ochre's from hydrated ferric oxides and compounds of red and black can source a range of umbers and browns. Brown is an important colour in order balance up the artwork. Just as with other colours brown needs to be layered on the picture surface in harmonious quantities.
There may be some heavenly asteroids brown in colour, but mainly when we think of brown we think of soily earth.
It is also a colour of muddiness and not one usually associated with clear focus.
So, hi-tech companies do not usually decorate their office furniture with a flood of browns. They prefer black and whites linked up with sharp greys. Then tailored to pristine peripheral decoration made up of blue reds and yellows.
Basically brown is rural not urban, so this is part of the reason, as an instance, why usually it does not sit well with

orange. It would have to be a wonderfully well designed piece of art that allowed these two colours to dominate and still be pleasing on the eye.

I mean orange townspeople enjoy the brown countrysiders' and vice versa, but they always know when to return home - they just don't like being forced on each other.

When in the country brown can be accommodating, a good homemaker a shrewd host and reliable friend. Brown does not usually make a good party guest because at parties there are usually brighter colours, and some with sophisticated airs which brown can either offend or be offended by. If brown has a party-piece it can shine. And brown is a hoarder so likes to hog bright opportunities when given too much leeway, so will swamp a yellow for example if given the chance.

Brown does have gems itself, but they are to be found in its cellars and so not on the surface. When in need of light, which brown often is, it can attach itself to brighter colours in helpful ways like being perky when next to turquoise, but generally it harbours negativity toward too much light, froth and bubble. Such

unwillingness for light-heartedness can lead to dysfunction, unhappiness even paranoia. It can feel taken for granted.

Brown is also a reactive colour so it loves to bask, as suggested, vicariously in the light of brighter colours like yellow and this is because brown is a survivor. And when this positive quality is enacted, say in a Rembrandt painting, a harmony with other brighter ones such as pinks, reds and yellows can happen and the result look brilliant. After all, those brighter colours mustn't complain too much because they need plainer colours such as brown to be seen as the bright things they are. Thus, when cajoled correctly, by an expert like the aforementioned Master Rembrandt, brown can be seen to be as generous as blue.
Brown does not appear in the colour spectrum, yet if it is a brown that has some natural element of yellow to it, like as if it is a tinge of the atmosphere, then it is from the sun after all and not at all of the earth. For this reason alone we have to allow more time and space for brown to evolve before we judge it too negatively, too harshly too quickly. To

discover that it was from the sun, for all its hubris, brown would love that.

turquoise
Occurs naturally in rocks especially Iran and in the USA, a semi–precious stone as well as metallic. And Aluminium and Copper phosphates turn turquoise too. Turquoise can be made from compounds of green, blue, white and yellow. Turquoise has a natural affinity with earthy green but also with lighter yellow and so reflects the characteristics of both of these colours. So it is of the earth and of the ethers too and not surprisingly, I suppose, it was used much for these reasons in Byzantium and *Classical* Greece, not least as a background colour behind scluptures.

It has many charms, a lucidity and clarity as well as cleanliness while at the same time and equally being robust and detached, even to the point of occasionally being aloof. Once again, as with other colours, when used in balanced proportions in a painting is when it shines most. Too little use of it and it can jump off the picture plane, especially when put next to say red. On

the other hand, where it used too much, it can imprison the spirit by being suffocating in quality. It also has a chilly quality about it and so can be used to cooling effect; no one would want too much of that.

Turquoise loves the company of pinks, reds, yellows, blues and greens and does not balk too much when close to more sombre colours such as greys and browns. White and black of course carry and define it superbly. Although given to headline hunting for its own celebrity occasionally, it does not do this as much as say red does which just loves to be in action most of the time.

White – a reference

When we talk about white, we can often talk about black. White and black are of the earth, our solar system, the universe. White, black are not regarded as colour because they are seen as carriers of colour instead. White contains and carries colours and delivers them to you, whereas black recedes; both define colours this way. Aside from white light carrying the spectrum, white it-self is one of the most abundant pigments on

the planet with the sandy pigment Titanium Oxide. Titanium Oxide appears in copious amounts in the Americas, Africa, Europe, India, and Australia.

There are lots of other substances where white can be derived from, such as Magnesium Oxide, but Titanium Oxide has a higher refractive index, which provides opacity. Opacity relates to the refractive index; the measure which a material can bend and return light, thus becoming opaque, consequently an ability to conceal its ingredients, which helps its brightness, its whiteness. For example, only diamonds have a greater refractive index. From a practical point of view, this means that any donor material such as paint, cotton, or concrete, plastics, paper, etc; even in large volumes will appear white when mixed only with a modicum of Titanium Oxide. Titanium Oxide is hence the most frequently used pigment of all.

It is unusual for anyone to refer to white as a favourite colour, because it is in a sense sterile and lacking in a personality. White, as with its equal opposite and complementary black, is there to assist with the proceedings of life and is not to be anchored to life with

any great personality as such of its own. White and black can, to their mutual pleasure, take up endless configurations together. White and black are like priests presiding over ceremonies and do not therefore become overly involved themselves, rather their job is to facilitate. If white or black do get overly involved with other colours, everything changes. And if not done properly as part of a dedicated process will turn most things grey, and then that would be a world of grey – and even grey may object to that.

So, our interaction with this earth, let alone art, is inextricably influenced by our relationship with white; and black.

Black – a reference

One, if not the most important elements for pigment use is carbon and it comes in many forms; from metals and minerals to vegetable sources, peach stones and almond cases. Or it can be derived by a flame as it plays on a cool surface, as then the sooty deposit can be collected, to be mixed with gum-water and a ready ink is made. Then black can be got from burned woods, charcoals to

compounds from colours like yellow red and green.

From medieval times ink was of prime importance for writing as well as panel painting.

As with white, black is a non- colour; it is a reference for colour. It is the ability of black to absorb things then lend its weight that is the key to its success. It has to work out correct proportion however, as too much can overwhelm, too little seem scratchy. To get the proportions right black has to sense the scale of a situation and thus its surroundings in a shrewd way.

When this is done it can be there with a sophisticated air as with Malevich's *Black Square on White Field*, 1913, Mondrian *Composition with Red, Yellow, And Blue*, 1928, as well as their colleague Kandinsky were deft exponents at this balancing act with black. They applied it with theosophy and anthroposophy in mind. Mondrian also used the grid lines of Manhattan as a pattern to design his work, gridlines he often used black to denote.

Black can lend a sense of the mysterious too when applied with aplomb. When

applied in the wrong proportions it can be awkward, perhaps gawky. It is known, for instance, that Mondrian would agonise for hours to ensure that his black grid lines were in the correct place, moving one or two as he did, and by miniscule distances to get things proportionally 'right'.

Then, to get the best from black it helps if it is made to feel jolly and that is part of the reason why Renoir used it much and referred to it as being the king of colours. His *Le Moulin de la Galette*, 1876. a case in point.

Black has a non-reflective quality too, thus allowing those more innovative colours to enjoy themselves in its company because black won't compete with them, rather allows them to be. Only rarely does black need to be glossy.

Other books

Other books being produced by Gordonart for other author's.

Dick Fleetwood:- Dodgie's Dead Red Fans – A Manchester Massacre.
The great rainy northern city is united while plagued by a sick scheme resulting in massacre. Rotor fans end-up dead, bloodied during the climax. Roman swords, Peterloo sabres, Luftwaffe and *IRA* bomb- shrapnel metal is mixed up with human molecules, masterminded by an evil Prof at the University of Manchester - a shocker adult book. A legendary detective from the south central police station tries to solve the case getting help from a deceased officer previously killed in a south Manchester shoot out. Another officer, DC Jaffers is one of the sexiest officers on the force using her sauciness to survive. This rainy city heart-racer wrestles with the eternal theme of 'good versus bad' as the plot unravels – a plot spanning the centuries.

The spectacular end-game culminates at the UK's tallest building outside London, the *Beetham Tower*.

Are you sitting safely, as safely as possible? And, if you are reading this in a hotel room please keep your wits about you when taking a shower. My thanks to Gordonart Ltd for producing this-book, and Amazon-Kindle, for publishing,

The sequel entitled: 'Dodgie' (sub-title, Dodgie's Dead Red Swords, another Manchester Massacre) – by Dick Fleetwood (a sequel to Dodgie's Dead Red Fans, a Manchester Massacre – currently being produced, available later in 2014

Stitched-Up, was the first book of short stories. This second book of short stories, *Blackpool Tower is Falling Down,* is again one that you can also read while sat on a bus, or at leisure and each story takes around ten to fifteen minutes to read.

Blackpool Tower is Falling Down, by Dick Fleetwood is again one that you can also read while sat on a bus, or at leisure and each story takes around ten to fifteen minutes to read. A mix of humour and philosophy enables, I think, life to

be seen for the temporariness of everything. Knowing this helps us to traverse the highs and lows in equal temper.

*** *** ***

Following books By Jerry Gordon:-

Little Art Book, Big Ideas

Little Art Book, Big Ideas hinges on what art is, and the artist that made it. I've written about art in other books such as, 'Colour Theory made Fact - *the Daubs'*. I refer to that and include a chapter in this book on colour.

Artists have a deeply engraved gift for spotting what others don't see. Artists make art that acts like a mirror, it reflects back at us and our experience. There are many mediums that do this such as, architecture, sculpture, acting, film, music, photography, (some cooking). I focus on painting mostly.

I have supplied three basic words to describe who the artist is and three words to describe what art is. In the final chapter I ask a question about the abstract painting at the front of this book - is it art? If you can answer that you can apply the

formula to any artwork, and thus you find this little book to be a trusty companion.

Mount Snowdon to Mount Kenya, (and back again): Sub Title: Love Mountain

An adventure for high altitude was one thing, art another, but another driver for the trip to Mount Kenya, (June-July 2014) was the thought of Mount Everest base-camp. If I could trek up Mount Kenya I could attempt a later trek to the biggest mountain of all in Oct'14, to help raise funds for FragileX. Research at the University of Edinburgh has identified a chromosome snag, that with the help of further funds it may be possible to unravel. Go to the FragileX website for further details.

In a nutshell if I couldn't climb Mount Kenya base-camp, at ~14,000ft, then attempting Everest base-camp at ~20,000ft for charity would be foolhardy. But I couldn't attempt climbing Mount Kenya until I'd trekked up Mount Snowdon, to gain confidence and build leg strength. Working temporarily near Mount Snowdon, on the holy Isle of Anglesey, came in handy. I climbed the island's Holyhead Mountain too - twice.

Another thing, last year my ex-partner lost our baby son in childbirth. Our relationship then sadly perished with loss of belief. We were heartbroken and found separate ways to find solace. She immersed herself in her social work caring job, I took time off work and drank too much beer to try and drown sorrows. But moping around is no use. As the saying goes, when you get knocked down you need to get up again. We tried to rekindle, bought a gold ring, became engaged for six months afterwards, but despite our noble efforts the birds of love and romance had flown the nest. At the beginning of 2014 we boxed-up respective belongings, emptied the shared house, and stood tall again as single people. I had been told many times that when the going gets tough, the tough get going. We would test such ideas, apart.

The physical exertions I was about to start were akin to a pilgrimage. I was preparing to bare my soul to god on a mountain. The great African sacred mountain was merciful. Sadness, negative thought-frames, were replaced with hope and love. I found love in a hopeful place, hence the sub title, Love-Mountain.

I hope you gain something by this book that may inform, help inspire your own life-story with its certain highs and lows. I have learned that when

walking in a valley, keep walking, the higher ground will meet you, and a bigger love exists, **Jerry Gordon**

To Manhattan, (and back again) **The United States of America** may be seen as a big material gobbler machine, yet great art is produced. The USA is much more complex and incredible than a cartoon character hungry for new ideas. The USA produces art, amazing art. Art because of its spiritualised nature points the way to a more permanent, enlightened existence. My proposition is that this shadowy difficult world is made more understandable and more tolerable, enjoyable by the existence of art. Jefferson's idea of enjoying life is contained with his 1776 declaration that with equal creation there are rights; "among which are the preservation of life, & liberty, & the pursuit of happiness". The UK, by comparison, contains no such statute, but does promote humanitarian rights to be happy. Art, happiness, and thoughtfulness are just a few ideas that I try and comment on in this e-book. And in my visit to Manhattan, (driving to get there across 18 states from San Francisco), I can say that the USA added to my understanding of life and art – and, I was happy there. I am writing about my

appreciation of the big country and the big-apple across the pond, out of respect and a hope that whatever you may think of America, you must agree that the world needs America to be the best it can be, because if America is the best that it can be, then the world benefits. This is largely true of all peoples in all countries, however, whether you choose to agree or not, Uncle Sam is a leader. I will mainly confine this book to the declaration of art, and describe efforts to make it, sewn into some autobiography. A significant theme of this book is paying respect to the places I have been, as with travelling through the 18 states of the USA culminating in Manhattan, and specifically atop the Empire State Building in 1986. I am including a chapter on 9/11 as this event hit every human nerve going all the way to the heart of humanity. I hope you glean something here and that it may inspire your own endeavours and that you enjoy this e-book *Jerry Gordon*

To Moscow, (and back again). **This** e-book is intended for you who have an interest in Moscow, European travel, and wish to see some drawings and paintings on sacred sites as well as the artist's explanations of how and why it has been done. In addition to Moscow there is an east-west

comparison with travel to Western Europe having been to Moscow. It is an e-book also intended to contribute to interfaith dialogue. And, for anyone involved in making an arts project it may assist because as this e-book shows that arts projects gain a momentum of their own as they move along. I hope I've illustrated this in order to help you attain your goals.

By 1994 I had made two largish *Sacred Sites* oil paintings, (4ft x 5ft), from earlier sketches. One was of St Basil's, Red Square, Moscow, from my visit there in 1989. The other was of the Anglican Cathedral, Liverpool. The Anglican Cathedral Liverpool was an easier proposition to paint since my studio at the time was located in that great Liverpuddlian city. Painting St Basils had involved a difficult journey there in 1989 as not many individual tourists journeyed there during what was still the Soviet Union. It was mainly a closed place other than booking a slot in a tourist group, but I preferred to drive there in my *VW Beetle,* which I did. I visited many other sacred sites in neighbouring countries in that 1989 tour. There was no doubt about it, *Sacred Sites,* as a distinctive arts project was coming alive. There would be many other travels and many other paintings, and details of these are contained in this

e-book. I hope that you find something in this work to inspire your own goals.

***To Delhi, (and back again)* – India is said to be the spiritual cradle of all humanity.** Now, having been there for a few months I can see why. And the capital, Delhi, I saw, is full of art. In regard to my arts project, *Sacred Sites,* I wished to contribute to peaceful understandings for I knew that there can be no greater concern than people killing each other, a carnage made worse when enacted for religion; that otherwise most loving of conventions. I was here as part of a world tour to add to my arts project of painting up sacred sites onto substantial canvasses to contribute to the idea that there is one humanity adorned with different views.

Delhi is full of religion. Religion - that part of society with many names in many different places, and having been the case, one way or another, for several millennia. I am claiming, the theology of each religion bears comparison - each claims to be loving; but wars continue in their name. This is where art can help to lighten the heaviest heart; aid peaceful imaginings. Appreciation of art can be cultivated like a friendship. An engagement with philosophy or

sport can do similarly, and halt some of the chaos all around. A key feature of art in all its forms is that attritions can be tackled by creative thinking. Art, and other disciplines like philosophy and sport, (surely cooking too), allows creativity. Who wants to fight when there is so much of human creativity to enjoy! Mind you, a serious bout of Delhi-belly, I admit, was not so enjoyable. Meeting the Dalai Lama on the other hand was a high point. All in all this trip of a few months was so enriching and I am sharing it to provide background for the paintings and exhibition(s) that followed.

As an architect you design for the present, with an awareness of the past, for a future which is essentially unknown **Norman Foster**

Overall, on those long journeys in the 1980s I had always sketched and photographed sacred sites, but without any distinct plan. In 1990 this changed. Eventually toward the end of a Spanish gap-year of 1990-91 things began clicking further into place. *Sacred Sites* was nearly ready to lift off. It had to wait until other projects had been sorted out first. To get *Sacred Sites* to begin its next phase. I needed money to make art dreams to

come true. I sold my house in 1995. I now had the funds to make *Sacred Sites* as an arts project happen.

To Pitcairn Island, (and back again). Following the worldwide media coverage in 1994, I am delighted that this project inspired others. **Adventure** was one thing, but art was the main driver for the trip to Pitcairn Island, one of the remotest Islands on earth. A main thing that I have learned with adventure and trying to make art is that there is always a greater scope of things and we may be small, but we are connected to that greater scheme. Travelling to Pitcairn was part of that scope. I was grateful to the Island community who showed me a great welcome, hospitality, and generosity of spirit. A significant theme of this book is autobiography in order to describe the motive; the attempt to make art, and a portrait of a long –dead mutineer, Fletcher Christian.

One Sunday afternoon, age 10years, watching TV enjoying pleasant family-life something clicked in my consciousness. The music may have helped dramatise this while watching the black and white film based on a true story from 1789, *The Mutiny on the Bounty*. This 1930s Hollywood film about

that legendary saga saw Clark Gable playing Fletcher Christian, and Charles Lawton playing Captain Bligh, here on our flickering TV set in the 1960s.

From this real-life 18th century maritime drama the mutineers found refuge on an uninhabited *Bounty* Island called Pitcairn. It was the tip of an extinct volcano - long abandoned by the Polynesians in the South Pacific Ocean, called, Pitcairn Island. It was so named by the British Navy in 1767 after the surname of a seaman who first charted it. One day in the future I'd visit this island, one of the remotest on earth, in order to paint landscapes and bring Fletcher Christian back to life by portraiture.

I am delighted that this project inspired others and I hope that my efforts to make art encourage you in your endeavours -. I particularly hope that you enjoy this e-book, **Jerry Gordon**

To Timbuktu, (and back again) – a promotional e-book to introduce the e-book 'From Blackpool Tower to Timbuktu, (and back again).' Adventure was one thing, art another, but the main driver for the trip to Timbuktu was to help raise funds for research at

the University of Edinburgh for FragileX. Further details can be found on the website, London to Timbuktu for Fragile X.

50 countries visited and now, along with a group of friendly individuals, I had just driven through the Sahara. With these muckers I had ventured deeply into the dark-continent. In this uncertain world there is no guarantee that you will return from any journey, large or small. Some intrepid adventurers like the Victorian, Alexander Gordon Laing, who made it all the way to Timbuktu, but sadly never made it back to his homeland of Scotland - he was slain en-route.

I write this promotional e-book to introduce the e-book 'From Blackpool Tower to Timbuktu, (and back again)'. The main thing I have learnt is a guess at the scope of things that are yet to be learned - a big scope. Travelling to Timbuktu was part of that scope.

A significant theme of this book is autobiography in order to describe the motive; the attempt to make art. I see no fixed issues, rather developmental journeys. I hope you glean something here and that may inspire your own endeavours and that you enjoy this promotional e-book, an introduction to the larger e-book, From Blackpool Tower to Timbuktu, (and back again).

Fletcher Christian – The Portrait – Until January 1994, no one knew what the infamous mutineer, Fletcher Christian, looked like. There were some written descriptions of him noted in Captain Bligh's log-book; nevertheless, Fletcher's *looks* escaped the general imagination. I stayed as a guest of Fletcher's descendents for 3 months on the *Bounty* Island as a part of an overall 5-month expedition to the South Seas in 1993. I would make an image of Fletcher. Then, in January 1994, with the help of Merseyside Police identikit computer, and filmed by the BBC, we created a computerised image of Fletcher, a world first. I fed the computer with my research of his ancestors and merged with the images of some of his descendents. I mixed in the living spirit of Pitcairn.

It has been my privilege to have then created a drawing of the mutineer, Fletcher Christian – the first to do so since he became infamous at the end of the 18th Century. There have been follow-on's, and claims of others of getting to make a 'portrait' first, but the record books will be evidence based on my work with the BBC, and Merseyside Police. I nevertheless respect, acknowledge later claims of others who have made the effort to

make a visual image of Fletcher. Art is free. I defend every artist's right to be creative, and so I support those who have built upon my expedition to Pitcairn in 1993 and my work to build a portrait of Fletcher in 1994. I too have sat on the shoulders of everyone linked to this story in order to make this project. We all have a contribution to make. The later duplicates demonstrate that there seems to be an enduring interest in the wish to record images of deceased celebs such as Fletcher Christian. For example, the *Daily Mail* newspaper contacted me in 1994 to enquire whether I would construct an image of Queen Bodicea. I declined that opportunity at the time as I was immersed in other arts projects. There is much scope for artists in this field.

My time spent researching Fletcher Christian, including a visit to Pitcairn Island in 1993 to meet his descendents seems not to have been wasted, but rather and humbly, it is my contribution to the overall saga. It is my privilege to present the world's first recorded image of Fletcher Christian.

*I presume, sir, in painting your beautiful portrait, you took your idea of me from my principles, and not from my person......***Abraham Lincoln**

From Blackpool Tower to Timbuktu, (and back again). A description of a journey, from Blackpool Tower to Timbuktu, and back again. It is a developmental journey, from boy to man. It starts from England's Fylde coast in Lancashire, whence I came. Here, in the North West region is the Victorian icon, Blackpool Tower, which, along with Liverpool's *Liver Building,* and Manchester's *Town Hall,* is un-deniably one of the UK's most prominent landmarks.

The narrative of cars, world travel, mechanised society, auto- biography, dealing with life. The tale is shoved along by the belief that the future is a wonderful place, and that each moment is freighted with the next step into the future. Moreover, that the past has to be seen in perspective to reference the future, and, above all, that we must cherish the present and live in it clutching dearly our ambitions, sharing progress and setbacks with our loved ones. In addition, not least, an underlying thread to this story is of trying to make dreams come true. Many a dream has swung around Blackpool Tower. In my book, Blackpool Tower stands for optimism.

London Underground Odes – an ode for each and every station. I loved Blackpool trams, and Manchester's equivalent, though these marvellous systems didn't carry as much pressure from criticism, passenger numbers, and from high expectations as the London Underground organism did. And for all its ills it has to be one of the most magnificent engineering masterpieces of its type anywhere. Like a great big piece of raw art. Every ticket holder, every train driver, every ticket machine, and platform cleaner, every advert, every piece of litter, every queue, every trodden toe, every discarded *Metro* newspaper, every overheard mobile phone call, every eastern European female beggar holding a child and an accordion somehow smiling making music, every shopper, every city gent scanning the financial times, every tourist peering at a tube map, every student carrying a draft dissertation and day dreams, every escalator shifting pan faced strangers; every tanoy telling you to 'mind-the-gap', all vital pieces of that crude artwork; those tube trains are blood vessels, those separate yet inter-connecting urgent electrified lines are veins of the capital's search for a reason for being – for all to be connected, in a big body, on the move, alive.

Painter Street - London Underground Odes – promotion version, a selection of odes from a few stations. The Main version has an ode for each and every station, (based on the 1998-1999 map)

Dreambook, (nine types of dream), about belief that our dreams occur to help us see a bigger picture. More than that, our dreams want us to connect to that bigger picture because we have a role to play in it – the universe. This is because we are braided to the universe whether we like to admit it or not. But, not all of our dreams connect us to it directly as say a computer connects to the world-wide-web. This is because some of our dreams are only about dwelling on details of our own individual lives firstly; others would likely not be interested in such machination. What people are more interested in is how to interpret their own dreams, and I am sharing my own dreams to earn trust. If I can do it, so can you.

---- ----

Published by **gordonart ltd** Produced in the UK. Paperback version printed in the USA.

www.ingramcontent.com/pod-product-compliance
Lightning Source LLC
Chambersburg PA
CBHW071749170526
45167CB00003B/987